ANGLO-SAXON
SCULPTURE

SHIRE ARCHAEOLOGY

2

Cover photograph
The Irton cross, Cumbria.

For Siobhan

Published by
SHIRE PUBLICATIONS LTD
Cromwell House, Church Street, Princes Risborough,
Aylesbury, Bucks HP17 9AJ, UK

Series Editor: James Dyer

Copyright © James Lang, 1988

ISBN 0 85263 927 9

First published 1988

Set in 11 point Times and printed in Great Britain by
C. I. Thomas & Sons (Haverfordwest) Ltd,
Press Buildings, Merlins Bridge, Haverfordwest, Dyfed

Contents

Acknowledgements

Readers familiar with the subject will recognise the very considerable debt the writer owes to Professor Rosemary Cramp. This introduction is informed by her published work and by the research led by her for the *Corpus of Anglo-Saxon Stone Sculpture*. I am grateful too for her permission to reproduce photographs taken for the *Corpus* and to Mr T. Middlemass, photographer to the Archaeology Department of Durham University. The cover illustration is generously provided by Christopher Morris. The photograph of the Hedda Stone (figure 17) is reproduced by courtesy of the Courtauld Institute.

List of illustrations

1
The study of pre-Conquest sculpture

It was the widespread 'restoration' of England's medieval parish churches during the latter part of the nineteenth century that revealed the scale of Anglo-Saxon sculpture to archaeologists. Built into the fabric of the churches, sometimes serving as foundations, sometimes as lintels or mere filling core, parts of carved stone monuments had been used by later medieval masons as handy ashlar in their rebuilding and patching. Bearing in mind that for every visible carved face displayed in a wall there are three hidden within the masonry, and that complete crosses were usually about six times the size of most surviving fragments, only a fraction remains of the original spread of sculpture in 1066. Yet in the stony counties of England, especially in the north and Midlands, the pieces are found in their hundreds. Compared with surviving Anglo-Saxon brooches, for example, the contemporary stonework represents a much larger class of pre-Conquest artefact.

The sheer weight and size of the monuments are significant since, unlike portable metalwork or ivories, stone sculpture usually remains near to where it was manufactured. This means that the ornament of a particular monument was current in that area; hence, local styles can be recognised and as a result sometimes contribute to the understanding of settlement, regional culture and even economic standing. Two examples illustrate how this application of sculpture studies can corroborate or challenge existing knowledge in related fields. Some of the earliest inscribed stones seem to be confined to monastic centres in Northumbria and confirm the Hiberno-Saxon tradition found in contemporary manuscript painting and recorded by Bede. On the other hand, in the Tees valley and Cumbria some stones carry depictions of Norse mythology which do not occur elsewhere in England but which have close Scandinavian parallels, suggesting a pagan Viking presence in that area which is hard to recognise in surviving literary sources.

Settlement scholars have sometimes tried to correlate the distribution of sculpture with place-name evidence. There are geological restraints which must not be ignored (little sculpture is found in areas barren of freestone) and the very wide date range of the carvings, from the seventh to the eleventh centuries, means that maps cannot easily relate to initial phases of settlement. In

the later pre-Conquest period some (but only some) carvings in areas of Scandinavian penetration display animal ornament or motifs which tally with contemporary Viking styles in Norway and Denmark. Modern research, however, may qualify such 'ethnic' labels and establish an insular or colonial context for the patterns. After all, Vikings did not carve stones in relief in Scandinavia until the end of the tenth century, whereas the art form had evolved in Celtic and Anglo-Saxon lands over hundreds of years.

The dating of the sculpture adds to the problems since very few pieces have inscriptions which would fix them as precisely as an associated coin. Moreover, only rarely is the sculpture discovered undisturbed *in situ* or during controlled excavation, so the dating by stratification that has been possible at Winchester, Jarrow and York is restricted. Dating has to be based on style and comparison with other media. Only the broadest date ranges are possible.

Even more caution is necessary in studying the iconography of the carvings. In the eighth and ninth centuries the sculpture was produced for the monasteries in the aftermath of the Synod of Whitby. The figure carving often shows considerable Mediterranean influence in the classical postures, the plastic high relief and, not least, the strict adherence to canonical precepts. The Christian iconography of this period is orthodox and conservative, the product of literate communities with continental ties. This kind of iconography continues weakly through the Viking period and we should not assume that the later carvings are entirely pagan or secular.

Purely pagan iconography is rare, although it tends to take the limelight. No Anglo-Saxon sculpture is pagan; only some from the Viking period, where Odin and Thor are nevertheless juxtaposed with Christian symbolism. Heroic references are more common since Sigurd and Weland were more compatible with Christianity than the Norse gods. These scenes present a problem since they pre-date the earliest saga and literary versions of their stories by hundreds of years.

The most recent work on the sculpture has concentrated on the identification of local workshops and on the methods used to carve and lay out the designs. This requires the kind of scrutiny and analysis that has been so long given to artefacts in other media, such as manuscript painting and jewellery. The grouping of carvings should not be a subjective exercise based on the judgement of the eye. We do not see the sculptures as the

Anglo-Saxons and Vikings saw them; many have traces here and there of the colour which once adorned them. The stone was coated with gesso and then pigment was added to give a polychrome appearance. Analysis of the sculpture in the future will include these facets.

The term 'Anglo-Saxon' is here used to denote the period between the coming of Christianity to England in the seventh century and the Norman Conquest of 1066. Viking pieces are now referred to as Anglo-Scandinavian since culturally they belong to the same insular tradition of the Anglian and Saxon stones with which they mixed.

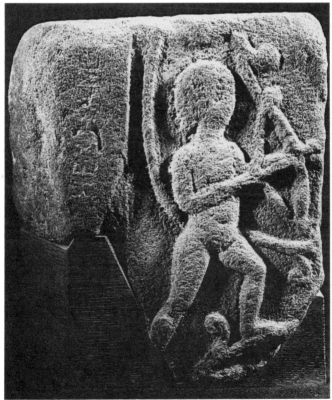

1. Hexham: architectural fragment from Wilfrid's highly adorned seventh-century church, deliberately decorated in a classical, European style. It was described as the finest church north of the Alps. (Photograph by T. Middlemass; copyright: R. J. Cramp.)

2
Form and function

Pre-Conquest carving is an applied art; it decorates a stone artefact. There are no free-standing statues and nearly all the sculpture is in low relief. The majority of Anglo-Saxon carved stones are funerary monuments set up as grave markers, as is known from the York Minster excavation which revealed a cemetery with the gravestones still *in situ*. Sculpture is rarely found outside an ecclesiastical site and is often the oldest indication of a Christian cemetery or early church. Some crosses may have served as cenotaphs, such as the one dedicated to Oedilburga, abbess at Hackness (North Yorkshire), and possibly the Bewcastle cross (Cumbria). Others may have had a function within a monastic enclosure, similar to some of their Irish high cross counterparts, especially the larger monuments like the round shaft at Masham and the great cross at Lastingham (both North Yorkshire), which were originally over 15 feet (4.5 metres) high. Biblical programmes on some crosses, for example Reculver (Kent) and Dewsbury (West Yorkshire), suggest a liturgical function rather than a commemorative one. Occasionally crosses act as boundary stones, such as Legs Cross by the side of a Roman road in County Durham and Rey Cross on the crest of the Stainmore Pass (Cumbria).

Architectural decoration

The habit of carving stone may have arisen when continental masons were introduced into England to build churches in the seventh century. Fragments at Hexham (Northumberland) and Ripon (North Yorkshire) may have adorned the Wilfridian churches there, and Bede tells of a rebuilding in stone at Lastingham that may be reflected in decorated door jambs surviving in part at the site today. Baluster shafts, turned on a lathe, occur in the Northumbrian monasteries, miniature versions being carved in low relief on string courses. In the ninth century an ambitious series of string courses was carved at Breedon-on-the-Hill (Leicestershire) with inhabited vine-scrolls and fabulous beasts, whilst at Britford in Wiltshire the door linings of a porticus in the church were enriched with panels of interlace and vine-scroll.

More rarely three-dimensional label stops are used to terminate hood moulds; a fine pair survives at Deerhurst (Gloucester-

O Berg

shire), and a similar protruding beast head surmounts the sundial at Escomb (County Durham). Sundials are usually plain, sometimes inscribed but rarely decorated. In the tenth century the exteriors of towers received plaques embellished with carving, especially in the churches of Earls Barton (Northamptonshire) and Barnack (Cambridgeshire). Proto-Romanesque capitals and friezes are found at Sompting on the West Sussex coast in the latest phase of architectural decoration before the Conquest.

Stone furniture

At Hexham (Northumberland) and Beverley (Humberside) 'frith stools' survive, once the thrones of bishops or abbots like that at Norwich Cathedral. Other stone chairs of composite slab construction have been found near monastic sites in Northumbria; at Lastingham an animal-head terminal is reminiscent of seats drawn in Hiberno-Saxon manuscripts. At Jarrow (Tyne and Wear) an impressive stone lectern was found in the excavation of the monastery. On a smaller scale there are some stone lamp-holders, chalice-shaped, which may have come from a secular context. At Ripon a closure screen post survives from the seventh-century church and at Hexham very classical panels depicting putti in a vine harvest may be re-used Roman work or the products of foreign masons brought in by Wilfrid.

Crosses

By far the commonest form of Anglo-Saxon monument is the free-standing cross, the four faces of its shaft carved, sometimes in panels, and the cross-head often showing signs of wooden prototypes in the domed bosses which resemble rivet heads. Wooden crosses did exist, for Bede speaks of one raised by Oswald at Heavenfield in Northumberland which had miraculous powers of healing (*Ecclesiastical History*). Some forms of stone cross echo carpentry models and techniques in their design.

The free-arm cross. Usually an Anglian form, the cross-head stands free. It appears early, in the early eighth century at Ruthwell (Dumfriesshire), and continues through into the later period. The shapes of the arms vary: some have an elegant cusp in their profile, others which are later in the series expand into fans and hammer-heads. A typology of cross-heads has been established by Rosemary Cramp (*British Archaeological Report* 49, page 17). The section of the shaft is usually rectangular and occasionally the original socket stones remain. The height can

vary from 3 to 20 feet (0.9 to 6 metres) so that some larger monuments are erected in a composite fashion with sections of the shaft slotted in mortise and tenon joints. The cross-head is fixed either in the same way or by an iron stay run with lead. Many crosses are monoliths, however, the most impressive being the Gosforth cross in Cumbria, which stands 14 feet (4.2 metres) high with a wheel-head.

The wheel-head cross. Imported by Viking colonials in the tenth century, the wheel-head cross originated in Ireland or the Celtic Western Isles. It has a more substantial structure and is easier to cut from a raw block of stone than a free-arm cross. Its ornament is often Norse-Celtic in flavour and its distribution is densest in areas of Scandinavian colonisation. It provides a useful dating criterion since it is unlikely to have appeared in England before about AD 920.

Varieties of wheel tend to cling together in local groups. The complete circle head rarely appears east of the Pennines, whilst an unpierced disc, the plate head, has a restricted distribution in part of North Yorkshire. In late Anglian sculpture, especially the Galloway series, the hammer-head arms of the cross form a circular disc head. Anglo-Scandinavian monuments of the wheel-head type rarely occur north of the Tees.

The round shaft and its derivatives. Some cross-shafts are cylindrical in section and may be skeuomorphs of wooden 'staff roods'. They are not simply local variants since they are found from Kent to Cumbria, though they are particularly common in the north-west Midlands. Many are sumptuously decorated with figure carving, for example the Yorkshire columns at Masham and Dewsbury which date from the ninth century. The Wolverhampton round shaft is rather later and florid, contrasting with a widespread group stretching from Staffordshire up to Cumbria in which the upper half of the shaft is squared off in section. The joint between the rectangular and circular sections is marked either with pendant swags or with a raised encircling band which may derive from rope bindings employed for bracing on the wooden prototypes. Later derivatives from this type stylise the encirclement into protruding steps and the rounded lower section tends to a rectangle with curved corners. Fine examples are found at Leek (Staffordshire) and Beckermet (Cumbria). Usually only the upper half is decoratively carved except for occasional 'vandyke' panels immediately below the swag, perhaps another

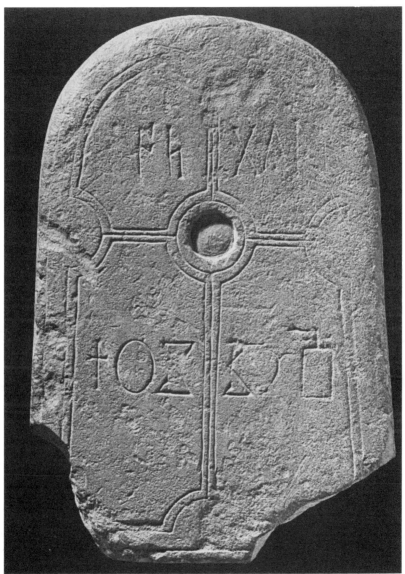

2. Lindisfarne: the 'pillow stone', a small stone identification slab placed by the corpse. Its cross is typical of Hiberno-Saxon art of the late seventh to early eighth centuries. Its inscription speaks of the literate community who produced it. (Photograph by T. Middlemass; copyright: R. J. Cramp.)

skeuomorph of metalwork applications to a wooden staff.

Recumbent monuments

Graves were often covered by horizontal stones, sometimes with small head and foot stones or small stumpy crosses placed at each end. The York Minster cemetery contained such composite arrangements.

Grave slabs. Flat slabs carved on only one face may possibly have served as upright cross slabs in the Manx manner but it is more likely that they were laid horizontally. They were in use in the pre-Viking period and it is also difficult to ascertain whether they formed the lid of a raised composite shrine in the shape of a box or lay flat upon the earth. One at Kirkdale (North Yorkshire) has a tasselled fringe carved round its edge, suggesting a pall draped over the shrine. Early and late slabs carry superimposed crosses which usefully divide the face into panels for ornament: the York Minster group is particularly rich in zoomorphic panels.

In the earliest period slabs could be very small indeed. At Lindisfarne cross-incised stones only a few inches across were inscribed and placed in the graves; although these are frequently referred to as 'pillow stones' they were not beneath the heads of the deceased. Hartlepool and York have produced series of rather larger slabs, which may have stood vertically and can be compared with the Irish sequences from sites like Clonmacnois.

Whole sarcophagi, such as the Derby coffin, are very rare but some slabs may have served as their lids or at least been stylistically influenced by them. Occasionally the plan was modified to give the slab a curved end, for example the monuments from Ramsbury (Wiltshire) and the Durham Chapter House piece. The tomb-lid notion may also account for the transitional form of recumbent stone: the coped grave-cover. The roof pitch is shallow and the plinth low, and the type survived well into the Romanesque period.

Shrine tombs. The coped slab is closely related to the house-shaped shrine tomb, a solid rectangular block with a pitched roof. The best example is the Hedda Stone in Peterborough Cathedral (Cambridgeshire), with its row of saints standing in an arcade in the manner of the metalwork shrines which have survived in such numbers on the continent. The shrine tomb may indeed be a skeuomorph of a metal reliquary. In Derbyshire they are decorated with free-style figure carving, such

3. Langford (Oxfordshire): the rood. This eleventh-century Crucifixion is monumental and the most sculptural of pre-Conquest carvings. In southern England such roods were given architectural settings on the walls of churches, hence the scale. (Photograph by T. Middlemass; copyright: R. J. Cramp.)

as those at Bakewell and Wirksworth.

The shrine tomb could also easily have evolved from the box or corner-post shrine: this was a composite monument of vertical slabs held by stone posts at the corners. As a type it is not exclusively Anglo-Saxon, witness the St Andrews sarcophagus, but survivals at Breedon-on-the-Hill (Leicestershire) and as far north as Jedburgh show how widespread the form was.

Hogbacks. In the Viking colonies of northern England an unusual recumbent monument evolved in the shape of a house with curved roof ridge and *bombé* plan. Some of the pitched roofs

are covered with representations of shingles and some have large end-beasts, perhaps bears, clutching the ends of the stone. They are found in a developed form in Scotland but seem to have been short-lived in England, confined to the Norse-Irish floruit in Yorkshire and Cumbria. One, at Gosforth, is very possibly a skeuomorph of an Irish shrine. Brompton in North Yorkshire was the likely centre for their inception.

Fonts

Rude tub fonts are not necessarily Saxon because of their primitive appearance. Pre-Conquest shafts have at times been re-used as fonts, as at Rothbury (Northumberland), though there can be no doubt in the case of Deerhurst's, which is lavishly ornamented.

Roods

In the latest phase of the pre-Conquest period a number of churches in the southern counties possessed stone Crucifixions of almost life-size dimensions. The Romsey rood (Hampshire) is the best preserved and is made up of several blocks of stone.

3
Ornament and date

In the absence of attributable inscriptions on so many of the monuments, stylistic dating is all that is possible. The repertoire of patterns and motifs can, when arranged in progression, give an internal chronological sequence based on stylistic development, even if fixed points are rare. Such sequences were established and given a time scale by Brøndsted in *Early English Ornament* (1924) and by W. G. Collingwood in his *Northumbrian Crosses of the Pre-Norman Age* (1927), but since then many more pieces have come to light and methods of dating have been refined, most recently by Rosemary Cramp whose 1978 article is essential for an approach to chronology. The local idiosyncrasies of the carvings mean that any chronology must allow for provincialism, archaism and individual experiment, so the clear-cut dating phases often put forward must be used cautiously.

Nonetheless, certain historical events did determine choices in design since the sculptor's patronage was either ecclesiastical or aristocratic throughout the pre-Conquest period. The missionary period with the Celtic church in seventh-century Northumbria, the English contacts with Carolingian Europe in the late eighth and early ninth centuries, the Viking settlements of the late ninth century and the Norman Conquest all left their mark in varying degrees on Anglo-Saxon sculpture, especially the Viking impact. It is often difficult to date by comparison with continental parallels in other media, such as metalwork and illuminated books, and with English analogues too, for the sculpture seems on occasion to have developed along separate lines, and there is always the problem of comparing widely differing scales.

Many of the patterns on the earliest pieces may be termed 'insular': that is, they belong to the repertoire of formal and zoomorphic ornament current in Britain and Ireland in the early medieval period and eschew imported classical features from the Mediterranean. The basis of much of this ornament is constructional geometry, as study of manuscript decoration has proved. Complicated interlace, often with long diagonal elements, crosses with expanded terminals, spirals and interlacing ribbon beasts are typical and can be found in Hiberno-Saxon manuscripts. The books may even have served as pattern sources for pieces like the Irton cross in Cumbria (cover illustration) and the fragment at South Kyme (Lincolnshire). It is a non-naturalistic style, even the

animal ornament, and is rigidly disciplined and balanced symmet-
rically. Examples are to be found on the panels of the Bewcastle
cross, the Hartlepool name-stones and a shaft from Lindisfarne.

The contacts between Rome and the new monasteries are well
documented and were reinforced by the Synod of Whitby. By the
mid eighth century classical elements had arrived, ultimately
from Rome and the eastern Mediterranean but more immediately
via architectural sculpture in the churches of Northumbria.
Modelled figure carving whose stance is determined by the
canons, like the principal panels of Ruthwell, and the vine-scroll,
usually inhabited by birds and small creatures, are indications of a
response to a centralised European church as patron. The cutting
techniques are equally classical with high relief and many curving
planes. The postures of the human figures are varied and often
hieratic, whilst the inhabitants of the scrolls are naturalistically
engaged in nibbling fruits. The vine-scroll was quick to evolve
into more purely geometric forms, as the Acca cross at Hexham
testifies, and it began to lose its leaves. The animals within it,
instead of perching, were inserted within the scrolls by locking
their feet in the scrolls in the manner of interlace. A comparison
of Otley (West Yorkshire) or Ruthwell with Croft or St Peter's,
York, (both North Yorkshire) vividly demonstrates this.

In the late eighth and early ninth centuries the classical
elements may have derived from imported Carolingian artefacts,
especially ivories, which consciously resurrected earlier Roman
fashions. Cultural contacts established during the eighth-century
English missions to the continent reached their peak with Alcuin,
summoned by Charlemagne to establish the Tours school. The
Easby cross in the Victoria and Albert Museum and many of the
fine miniature styles in Yorkshire reflect this European connec-
tion. Further south, in Worcestershire, the Cropthorne cross-
head relies heavily on manuscript art from mainland Europe.
Later still, in the south, the acanthus leaf found its way eventually
into carving of about the year 1000, such as the Sompting frieze,
no doubt by way of Winchester-style manuscripts.

The arrival of the Viking settlers in the 870s and early tenth
century was not the iconoclastic trauma that might be expected.
In northern England 80 per cent of the surviving sculpture is from
the Viking age, against the 20 per cent culled from the earliest
and latest periods. There was no tradition of stone relief carving
in Scandinavia, so it appears that the art form was assimilated by
the incomers, who, for the most part, were colonials brought up
in the west, probably Ireland, and who during the supremacy of

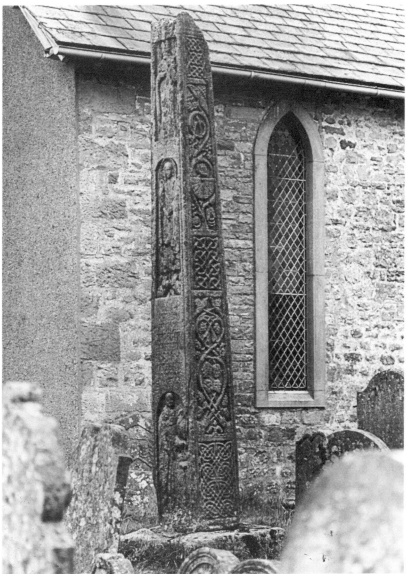

4. Bewcastle cross. The vine-scrolls and classical drapery of this eighth-century shaft in Cumbria have their origins in the Mediterranean. Centres like Jarrow and Hexham had strong continental links which provided a channel for such influence. (Photograph by T. Middlemass; copyright: R. J. Cramp.)

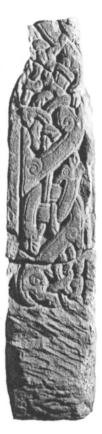

5. (Left) Dacre (Cumbria): inhabited scroll. This later version of the vine-scroll inhabited by fabulous beasts has the animal growing in importance and treated in a more plastic way. (Photograph by T. Middlemass; copyright: R. J. Cramp.)

6. (Right) York Minster: Anglo-Scandinavian beast-chain. From the Viking period these interlocked ribbon beasts are constructed on a grid in the insular manner, though with Jellinge-style details from Scandinavia. (Photograph by A. Wiper; copyright: R. J. Cramp.)

the York kingdom preserved close links with Dublin. Consequently they not only introduced their own taste for Jellinge-style animals and simple closed plaits but also brought about a revival of insular patterns, which were re-introduced on to the English monuments. Fret patterns, last seen in the Hiberno-Saxon period, reappeared along with symmetrical abstract interlace patterns.

The Scandinavian presence did not oust the Anglian tradition either. In ninth-century Mercia animal ornament had evolved into large heraldic quadrupeds with trailing extensions to their substantial bodies. They were sometimes placed one above the other. In the Anglo-Scandinavian carvings these beasts are still to be found, for example at Gainford (County Durham) and Nunburnholme (Humberside), and they develop into more ribbon-like forms to form beast-chains in Jellinge style such as appear at York. The Jellinge animal's diagnostic features of contoured outline, scrolled joint, fettering and body extensions are all matched by earlier Hiberno-Saxon beasts; hence, the arguments over the origin of the style still rage, with the northern sculpture at the centre.

Alongside this dynamic animal decoration and plaitwork, the Anglian portrait continued robustly. The Newgate shaft at York and some sculpture from the Minster have heads with dished halos adjacent to Jellinge dragons, even the cutting styles contrasting on a single monument. Closed circuit plaits, twists and ring-chains are more common, however, in the Danelaw area. When in 954 the Viking dominance was ended, there was a return to the old styles, but it was stale, often crudely accomplished and too weak to withstand incoming Romanesque.

In the south there was more experiment in the latest stages of the pre-Conquest period. Knut's brief reign brought a burst of late Viking energy that failed to extend northwards. But it was incipient Romanesque that took hold in the coastal counties of the south, with huge roods carved with considerable modelling and trials with related three-dimensional masses, as at Sompting (West Sussex). Decorative motifs and embellishing patterns had at last given way to sculptural form.

4
Iconography

Figure carving in pre-Conquest sculpture consists of either portraiture or illustration. On rare literate monuments identification of the persons and the scenes is facilitated by inscriptions, so that we can be sure, for example, that the panels at Ruthwell contain the saints Paul and Anthony in the desert, the Flight into Egypt and particular scenes from the life of Christ. Some of the fragments at Dewsbury are similarly inscribed and monuments such as Otley I and Masham have blank panels which probably once bore painted labels. These are informed carvings iconographically, as their literate associations indicate, and their composition usually conforms to the canons laid down on how biblical scenes should be depicted. Christ in Majesty invariably wears his crossed halo, bestows an orthodox blessing raising the correct fingers and is careful to carry the book in his left hand with his robe intervening. This conformity is a mark of the earlier carvings when all the monuments were produced by monasteries and ecclesiastical centres which had strong links with Rome.

The monastic context is confirmed sometimes by portraits of the monks themselves: at Halton in Lancashire and at Otley kneeling monks in cowls venerate angels who hold books, perhaps the rule itself. Sometimes the kind of monasticism seems closer to the Celtic tradition, often at a surprisingly late date considering the outcome of the Synod of Whitby, for at Winwick (Cheshire) a priest is seen carrying small bells similar to the Irish varieties and at Stonegrave (North Yorkshire) another wears a reliquary or book satchel round his neck. It would be in the monasteries too that biblical and liturgical sources for the iconography would be readily available. Not only would the orthodox canons be adhered to in such contexts but theological intentions could underlie the choice of scenes. Frequently the panels are arranged in programmes, perhaps based on a theme or a particular psalm that related to some liturgy. The Ruthwell programme has been shown to refer to the theme of the desert, at Dewsbury a series of Christ's miracles is presented and at Masham an Old Testament sequence including David and Samson was placed beneath Christ and his apostles. New Testament scenes are more common, as at Halton and nearby at Hornby (Lancashire) where the loaves and fishes are depicted. Because space is restricted in a shaft panel the design is often

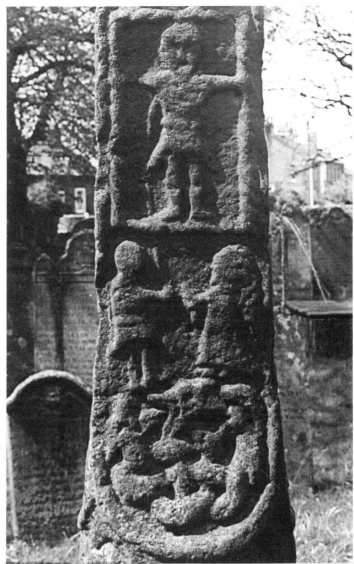

7. The Gosforth cross: Crucifixion. Christ is not nailed, the emphasis coming on the spear. The female figure may be a Valkyrie who traditionally welcomed heroes to Valhalla, implying an overlap with Odin. (Photograph by James Lang.)

crowded, as it is in the Ascension at Rothbury (Northumber-
land).

This narrative carving began early with the Reculver column in
Kent but, perhaps because of the limits imposed by the form of
the monument, portraiture was the more successful. The Wirks-
worth shrine fragment in Derbyshire shows how crowding can
add complexity to an already subtle programme. The Otley busts
on the other hand lend themselves to more coherent sequences,
so apostles with dished halos and evangelists, because they are
traditionally grouped in even numbers, are more suitable for
crosses. Often the arms of the cross carry the evangelists'
symbols: the man for Matthew, the lion for Mark, the bull for
Luke and the eagle for John. Grouped about a Majestas or a
Lamb in that position they reflect the descriptions in the
Revelation of St John. This can be seen at Hart (Cleveland) and
at Otley.

The Crucifixion is rarer than one would expect. In early
carvings it usually occupies a position low down on the shaft, as at
Ruthwell and the Spital cross at Hexham. In the tenth century it
tends to occur on the cross-head itself, which is usually of the
wheel variety, and the tradition may have been brought in from
the west by Viking colonials. One of the most interesting
Crucifixions is that on the Gosforth cross (Cumbria), where there
are overtones of Scandinavian pagan overlap in the iconography.
The frequency of Crucifixions on Viking age sculptures goes far
in confirming the Christianity of the patrons. Usually the
iconography belongs to the insular tradition of the standing
clothed Christ, erect upon the Cross. In the south, in the late
pre-Conquest period, continental influence through ivories and
manuscripts led to the depiction in the loincloth and the hanging,
bent disposition. Transitional forms are found at Romsey in
Hampshire and in that county one finds the large roods which
were incorporated in the walls of the churches.

In the south, too, at that time, in the wake of the Winchester
reform movement, angels begin to appear in the sculpture used to
adorn churches. They often fly horizontally, for example at
Bradford-on-Avon (Wiltshire) and Winterbourne Steepleton
(Dorset), though standing ones occur at Deerhurst (Gloucester-
shire) and Breedon-on-the-Hill (Leicestershire), the latter giving
a Byzantine blessing. In the eleventh century a revival of
ecclesiastical iconography reached the north but it is not always
canonically correct: the angel at Shelford (Nottinghamshire) is
moustached and blesses with the wrong hand.

Perhaps in response to imported Carolingian ivories, the Virgin and Child motif becomes more popular from the ninth century onwards. Dewsbury has an early example and at Nunburnholme (Humberside) a primitive Anglo-Scandinavian depiction provided the model for a yet more rustic version at Sutton-on-Derwent nearby. Further south the motif occurs at Shelford in Nottinghamshire and Inglesham in Wiltshire, both late sculptures. The Child in all these examples sits naturally upon the Virgin's knee, very much the mother and baby rather than the imperial 'floating Christ-child' model found on the continent. Hence the sculpture's iconography preserves the early insular tradition found on St Cuthbert's coffin and in the Book of Kells. The cult of Mary must have arrived early since at Hovingham (North Yorkshire) an arcaded panel contains scenes from her life, and at Breedon a strange portrait bust may be Mary, to judge from her head-dress, though she holds a covered book and offers a tentative blessing.

Symbolic iconography is more perilous to interpret. Most would agree that the vine-scroll relates to Christ's utterance 'I am the true vine', but how well later sculptors remembered that symbolism is debatable for its treatment evolves into decorative geometry. At Croft-on-Tees and Cundall in North Yorkshire there are bush vines reminiscent of others in the east Midlands, like those at Fletton (Cambridgeshire). They could have evolved from the bush vines which grow from chalices and are flanked by peacocks, found in the eastern Mediterranean where they stand as a eucharistic symbol. At Croft the peacocks are confused with the inhabited scroll and the chalice is a mere stump, suggesting that it has been copied simply as a decorative motif. In Anglian sculpture one finds an archer occasionally aiming at the creatures in the vine-scrolls: an early example appears at Ruthwell, and the tradition continues through the Sheffield shaft and the cross at St Andrew Auckland (County Durham). Interpretation is more problematic here and the cautious may keep silent, as they should when a ring of five bosses in the centre of a cross is identified as Christ's five wounds.

The liturgy is rarely depicted. There is a mass scene at Nunburnholme and possible baptism rituals on the Durham cross-heads. Attitudes of prayer range from the kneeling monks to an orans figure at Stonegrave. Such carvings should perhaps be considered in relation to the possible functions of the stone crosses.

The change in patronage which came with the Viking settle-

ment is reflected in the sculpture's iconography. In place of saints seated under arcades there are warriors on their weapon-cluttered high seats; this transition can be seen on a single monument at Nunburnholme. In place of biblical narrative are hunt scenes and occasional pagan-cum-heroic illustrations. Secular figures are usually depicted armed with sword or spear, a group at Sockburn (County Durham) being particularly obsessed with warriors. There a hogback shows two Viking cavalrymen with lances; other shafts showing spearmen have parallels in nearby villages. One of those analogues, at Brompton, is juxtaposed with carvings of clerics which should prevent us from attributing a pagan label to any carving of a warrior. Portraits of warriors, such as the Middleton panels in North Yorkshire, may be secular reflexes of depictions of saints, but at Gosforth and Lowther (Cumbria) illustrative carvings of armies, one of them in a ship, have parallels on the Gotland picture stones of the pagan Viking period.

Recognisably pagan scenes are few and always from the Viking period. At Sockburn there are stones referring to the gods Tyr and Odin, both associated with the warrior cult. More frequent in Yorkshire, Lancashire and the Isle of Man are heroic allusions to figures such as Sigurd the Volsung and Weland the smith. Since these heroes were not gods their iconography was deemed quite compatible with Christian motifs, so that we find the Crucifixion placed above Sigurd's roasting of the dragon's heart. At Leeds the heroic iconography was intertwined with conventional Christian devices: both strands are concerned with flight so that the flying smith, Weland, is related to angels and the eagle of St John. This kind of subtle combination was extended to pagan iconography too. The Gosforth cross illustrates Ragnarök, the end of the Norse gods, but the programme culminates in a Crucifixion. Similar overlap of pagan and Christian iconography occurs at Sockburn and Halton.

Hunt scenes appear in Yorkshire sculpture in the tenth century, perhaps copied from Celtic monuments in the lands recently vacated by the settlers. A stag hunt is the only kind chosen, such as those at Middleton and on the Heysham hogback, and the Irish and Scottish parallels suggest that this iconography is a colonial Viking manifestation rather than an importation from Scandinavia. The stag hunt is usually reduced to the 'hart and hound' motif where a stag is leapt upon by a single dog. So common is this device in Yorkshire, Lancashire and the Isle of Man on funerary monuments that it is tempting to see it as

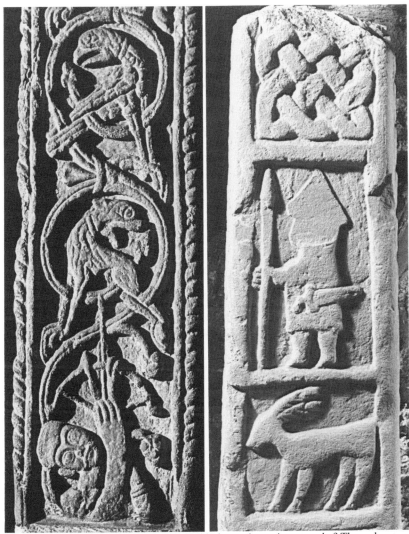

8. (Left) St Andrew Auckland: archer. Is this decoration or iconography? The archer may be symbolic, a reference to one of the psalms, or it may simply be a human extension of the inhabited scroll. (Photograph by T. Middlemass; copyright: R. J. Cramp.)

9. (Right) Sockburn: warrior and stag. In the Viking colonies of Cumbria and Yorkshire the stag often appears, sometimes in a hunt scene. Here it is alongside a secular figure, where it may stand for nobility or the death of a man as noble as the stag. (Photograph by T. Middlemass; copyright: R. J. Cramp.)

symbolic. It has been interpreted from both Christian and pagan points of view and it must remain an enigma.

The insular and particularly western sources for much of the Viking age iconography, be it the position of the Crucifixion, the riding warriors or the stag hunts, tie in with the origins of the contemporary ornament. It reaffirms the insular nature of late pre-Conquest sculpture.

10. Hartlepool name-stone. (Photograph by T. Middlemass; copyright: R. J. Cramp.)

5
Anthology of sculpture

The pieces chosen for illustration and discussion are intended to show the chief developments in the sculpture's evolution and to be examples of methods of approach to the subject. Fuller accounts will appear in the British Academy's *Corpus of Anglo-Saxon Sculpture* and in local articles. The choice also reflects the distribution of the carvings, with the bulk in the north and fewer in the south.

The Hartlepool name-stone, Durham Cathedral Library.
Hartlepool was the site of one of the Aidan monasteries established on the lines of the Celtic church. It is not surprising, therefore, that these small inscribed slabs of about AD 700 should echo Hiberno-Saxon manuscript art. The cross with semicircular expanded terminals is found on one of the Lindisfarne Gospel's carpet pages as well as on the Irish series of similar name-stones from Clonmacnois, although their inscriptions point to a much later date than the Hartlepool stones.
Cross-incised and inscribed stones of this size, equally smooth and carved on only one face, have been found under York Minster. They are rather larger than the so-called 'pillow stones' from Lindisfarne but should be compared, for they have the same combination of expanded cross and inscription, sometimes runic.
Later small grave markers tend to have no inscriptions but the ornamental repertoire grows more elaborate with interlace additions to the cross and border. Whilst it is difficult to speculate on their original disposition in relation to the grave, the later varieties probably served as end stones, perhaps in combination with a recumbent slab. This was certainly the arrangement in the eleventh-century cemetery under York Minster.
Brown, G. Baldwin. *The Arts in Early England,* volume V, 58-101. John Murray, 1921.
Cramp, R. J. *Corpus of Anglo-Saxon Sculpture,* volume I, 97-101. Oxford, 1984.

The Ruthwell cross, Ruthwell church, Dumfriesshire.
Together with the Bewcastle cross, which still stands in its socket on the Cumbrian fells, the Ruthwell monument represents the highest quality of carving and the subtlest of iconographic programmes of early Anglo-Saxon pieces. Its principal faces are

divided into panels which contain powerful figure and illustrative carving, each labelled on the moulding. The scenes include Christ in Majesty treading down the beasts (a spectacle repeated at Bewcastle), Mary Magdalene washing his feet, the Flight into Egypt, healing miracles and, low down, the Crucifixion. The cutting is deep with many inclined planes to create an illusion of depth and considerable modelling. The Christ portraits are monumental, even statuesque, with heavy folds in the drapery, very upright postures and an emphasis on vertical line in the composition. The carving of the Magdalene, however, is surprisingly different, almost modern in its bold treatment of mass and abstract form.

The sides bear beautiful inhabited vine-scrolls with delicate curling shoots and naturalistic feeding birds and creatures. The border moulding of the vine-scroll is cut with runes which spell out sections from the Old English poem *The Dream of the Rood* in which the Cross speaks of its ignominy, of Christ heroically leaping up to grasp it and, after the pain, of its transformation into a glorious bejewelled rood. Clearly the Ruthwell cross is a product of a particularly literate community, not only on account of the poem but because the iconographic programme, which some have seen as cleverly containing references to the desert or to biblical texts, depends upon a very well read patron.

Stylistically there are links with Jarrow (Tyne and Wear) and Hexham (Northumberland) but the monument stands distinctively as a high point with only Bewcastle as a challenger. Scholars have discussed both crosses exhaustively: the bibliography here provides only a starting point.

Brown, G. Baldwin. *The Arts in Early England*, volume V. John Murray, 1921.

Saxl, F. 'The Ruthwell Cross', *Warburg and Courtauld Institute Journal*, VI (1943), 1-19.

Mercer, E. 'The Ruthwell and Bewcastle Crosses', *Antiquity*, 38 (1964), 268-76.

Cramp, R. J. *Early Northumbrian Sculpture*. Jarrow Lecture, 1965.

The Jedburgh slab, Museum of Jedburgh Abbey, Jedburgh, Roxburghshire, Borders.

Originally this fragment may have formed part of a composite box-shrine made up of posts and slabs. Whilst its form is a common one in the Celtic north and west, the Jedburgh piece's ornament is thoroughly Anglian and has been recognised as a

11. (Right) The Ruthwell cross. (Photograph by T. Middlemass; copyright: R. J. Cramp.)

12. (Below) The Jedburgh slab. (Photograph by James Lang.)

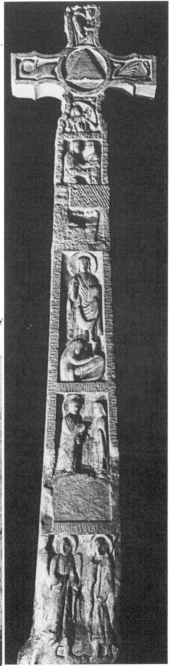

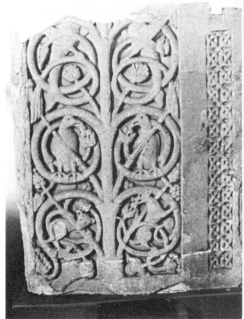

developing version of the designs found at Ruthwell and Jarrow. The panel here is broader and admits a double register of inhabited scrolls on either side of a pillar-like stem : a bush vine whose tendrils spring from trumpet nodes yet form very formalised roundels to contain the perching creatures. There are seed pods and berries which are reminiscent of the Jarrow-Ruthwell styles but there are no leaves on the plant itself, an indication of the gradual departure from the east Mediterranean models of the earliest vine-scrolls. Leaves do terminate some of the beasts' tails, though for the most part the animals are recognisable species, especially the mouse in the lower corner.

The narrow border strip of fine interlace can be compared with contemporary manuscript decoration from Northumbria, such as the frames round the David portraits in the Durham *Cassiodorus,* a Jarrow book of the early eighth century. The juxtaposition of insular interlace and Mediterranean-inspired inhabited scroll is typical of Northumbrian sculpture in the Bedan period; here the two traditions appear together but are kept separate, as they are at Bewcastle. The style of cutting is classical in its deep penetration, modelling and plasticity. The rather stiff formalised treatment places it rather late in the sequence, say about the middle of the eighth century. Its presence in the Borders reminds us of the extent of Anglian culture at that period.

Radford, C. Ralegh. 'Two Scottish Shrines', *Archaeological Journal,* 112 (1955), 43-60.

Cramp, R. J. *Early Northumbrian Sculpture,* 11. Jarrow Lecture, 1965.

The Otley shafts, Otley, West Yorkshire.

The earliest shafts in the important collection at Otley recall strong Mediterranean influences in their motifs and cutting techniques. One shaft has a series of busts, each under its arch and very classical in its drapery folds and figure style. The heads are turned alternately in half-profile, and undercutting and plastic modelling accentuate the effect of high, almost three-dimensional relief. On some busts remains of gesso coating and pigment survive, hinting at the original polychrome appearance of pre-Conquest monuments. The habit of colouring sculpture persisted from the earliest phases, as at Reculver, to eleventh-century pieces in York which were daubed with haematite.

The second Otley shaft also has a portrait head, with a dished halo to create illusions of depth through catching shadows. Above this naturalistic carving is a single fabulous beast with

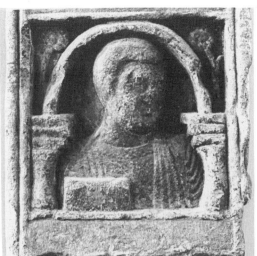

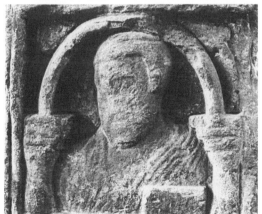

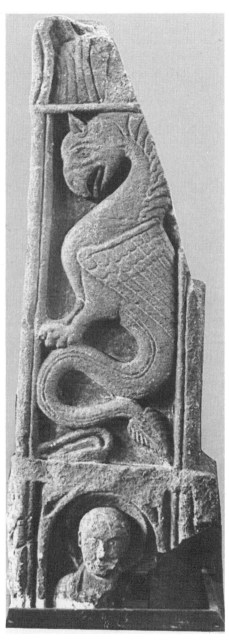

13. The Otley shafts. (Photographs by R. J. Cramp.)

wings, eagle's bill, lion's paws and serpent's tail. The origins of this beast lie far to the east and may have been available to the Otley sculptor through imported textiles, though a similar animal is found in Franco-Saxon manuscript painting of the late eighth and early ninth centuries. The carving is modelled in the same way as the portrait head.

On the side of that shaft the borrowed beast has succumbed to modification to Anglo-Saxon taste. A pair of them are placed end to end, their serpentine tails now transformed to interlace, their cutting style much flatter. The beast reappears at nearby Ilkley and progresses into the Anglo-Scandinavian series via the York Minster grave slabs. The sides of the other shaft have much more naturalistic animals contained in the organic growth of a vine-scroll and a plant-scroll which begins to adopt geometric medallions in its interlacing shoots.

Collingwood, W. G. 'Anglian and Anglo-Danish Sculpture in the West Riding', *Yorkshire Archaeological Journal,* 23 (1915), 224-8.

Cramp, R. J. 'The Position of the Otley Crosses of English Sculpture of the Eighth to Ninth Centuries', *Kolloquium über spätantike und frühmittelalterliche Skulptur,* Mainz (1971), 139-48.

Architectural sculpture, Britford, Wiltshire.

The decoration of stone churches provided the impetus for some of the earliest Anglo-Saxon sculpture, and the custom continued up to the Conquest. At Britford the carvings are still *in situ* in the jambs of an arch leading into a porticus from the nave. Two long pilaster slabs line each edge, decorated with a vine-scroll whose grape bunches are formalised almost into leaf-shapes filled with pellets. The classical motif has undergone a transformation into a more native tradition.

Set between the uprights are small square panels filled with interlace, the recessed spaces between left free to create an openwork frame. It is an ornate rendering of a feature that in timber may have been structural but here, in stone appliqués, must have been created for decorative effect. It could be compared with the pilasters of Anglo-Saxon towers, and indeed at Barnack in Cambridgeshire elaborate carved panels are used in conjunction with the raised strips that cover the surface.

The repertory of ornament used at Britford is that employed on cross-shafts, unlike the earlier Northumbrian string courses, at Hexham for example, where the miniature baluster-shaft motifs

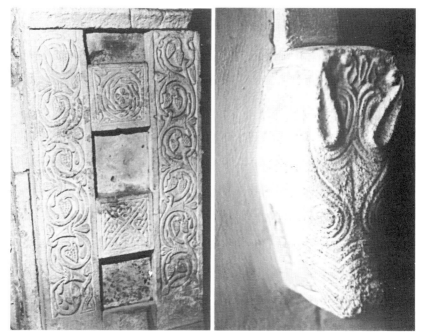

14. (Left) Architectural sculpture, Britford. (Photograph by James Lang.)
15. (Right) Church furnishing, Deerhurst. (Photograph by James Lang.)

are culled from actual lathe-turned cylinders of stone used in the furnishing of the church. At Sompting remnants of a frieze have acanthus leaves that echo the borders of Winchester-style manuscript pages. So there is no particularly 'architectural style' in this kind of sculpture.

The Britford panels are usually dated to the earlier part of the ninth century. Certainly in the late pre-Conquest period the place had royal associations which might explain such extravagant embellishment. Vine-scrolls were also used on lintels or door-jambs at the monastic site of Lastingham in North Yorkshire.

Brown, G. Baldwin. *The Arts in Early England,* volume II, 207. John Murray, 1925.

Cramp, R. J. 'Tradition and Innovation in English Stone Sculpture of the Tenth to Eleventh Centuries', *Kolloquium über frühmittelalterliche Skulptur* (1972), 141-3.

Church furnishing, Deerhurst, Gloucestershire.

The Saxon church at Deerhurst, one of two, underwent a series of extensions and rebuildings within the pre-Conquest period. At its height it was a very decorative church with figure panels set in the walls, perhaps painted, label stops to the hood mould and a superb tub font.

The wall panels include an angel whose parallels are to be found in the south, where they may have been used in association with a rood. The Deerhurst angel is unusually upright, unlike the flying, horizontal ones that echo Winchester-style drawings. Over the west door is a plain but modelled carving of the Virgin and Child, the face and the roundel for Christ being trimmed flat. This may be later desecration but the possibility remains that the surfaces were painted, in the manner of the Breamore rood.

The label stops are no longer in their primary position but must originally have occupied a similar location as terminals to a hood moulding. Very primitive versions survive at Dunham Magna in Norfolk, hardly comparable in quality with the Deerhurst beast heads. The snouts are slightly turned in towards the doorway and the lines engraved upon their surface, like a livery, sweep round the main features of the head. Streamlined curves follow the contours of the jaws and ears; there are tapering elements which convey movement yet underline the function of the corbel. Traces of red pigment can be found in the crannies of the carving.

The font is remarkable as a rare and early survival. Part of it may have once been a fragment of a cross, but the bowl expands like a font and the decoration fits it well. The spiral motif is found in Celtic and Northumbrian art of the Hiberno-Saxon period and occasionally erupts in southern manuscript painting.

Gilbert, E. *A Guide to the Priory Church and Saxon Chapel, Deerhurst, Gloucestershire.*

Knowles, W. H. 'Deerhurst Priory Church', *Archaeologia*, 77 (1927), 141 ff.

The Breedon sculptures, Breedon-on-the-Hill, Leicestershire.

The carvings at Breedon-on-the-Hill are the most important of the ninth century. They range from animated friezes to shafts and shrine panels, and they are cut in a variety of styles. The figure carving is particularly sensitive, with light draperies and graceful postures, a feature of related sculpture in the east Midlands at Fletton and Castor. Undercutting and drilling render the figures almost in three dimensions and the sculptors have been sufficiently confident to create very thin bands of stone in high relief. The

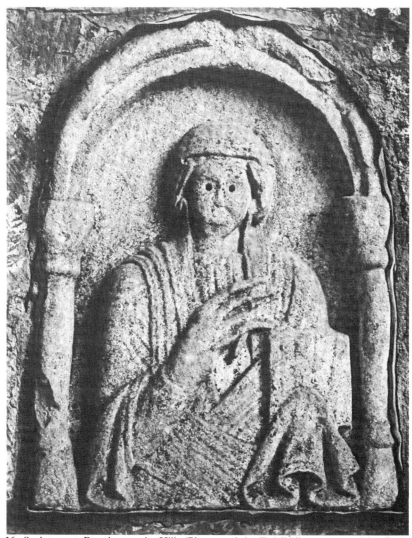

16. Sculpture at Breedon-on-the-Hill. (Photograph by T. Middlemass; copyright: R. J. Cramp.)

connections with continental art are marked, which is not surprising in the period around 800 when Carolingian and English links were strong. In the north the influence of ivories is seen on monuments like the Easby cross and in the Midlands manuscript parallels are to be found, both from England and the continent.

The motifs on the frieze include spiral scrolls, inhabited scrolls with elegant birds and beasts standing but locked into the tendrils, and fret and pelta patterns. It is possible to trace the ultimate source of the designs to the Near East yet the treatment is distinctive enough and the knowledge of the medium so sound that the carving need not be the work of foreign craftsmen. Certain techniques, like the drilling and openwork, do, however, resemble ivory-working mannerisms transferred to soft stone.

The portrait bust presents difficulties since its iconographic presentation confuses two distinct elements. There is no halo and the head-dress belongs to the Byzantine type which is frequently given to the Virgin Mary. On the other hand, a book is carried in draped fingers and a blessing bestowed, not features normally associated with Our Lady. The handling of the figure is subtle: the head is very slightly tipped and the shoulders and head are chiselled into humped masses rising from a spacious background. The angle of the drapery folds and their slim lines were to be echoed later in the north at Nunburnholme.

Clapham, A. W. 'The Carved Stones at Breedon-on-the-Hill, Leicestershire, and their Position in the History of English Art', *Archaeologia*, 77 (1927), 219 ff.

Cramp, R. J. 'Schools of Mercian Sculpture', in A. Dornier (editor), *Mercian Studies*. Leicester University Press, 1977.

The Hedda stone, Peterborough Cathedral, Cambridgeshire.

Composite box-shrines, composed of stone slabs, were used to inter translated saints at quite an early period. Their relationship to metal reliquaries and to sarcophagi lies chiefly in the house shape and pitched roof. Solid stone versions which resemble the reliquaries in external appearance are common throughout the British Isles and comparison with objects like the Brunswick casket, an Anglo-Saxon ivory box, points to the Hedda stone being a skeuomorph. The sides are arcaded and have standing figures who are very much in the mould of the Breedon and Fletton carvings. It is a conventional European way of adorning the side of a shrine and it may have influenced the design of some arcaded shafts in the Midlands and north during the ninth century, for example at Masham (North Yorkshire) and Dewsbury (West Yorkshire).

Solid shrine tombs tend to be more common in the Midlands than in Northumbria. In Derbyshire the classical appearance of the Hedda stone gave way to freer historiated carvings with illustrative scenes and an absence of arcades. Two fragments

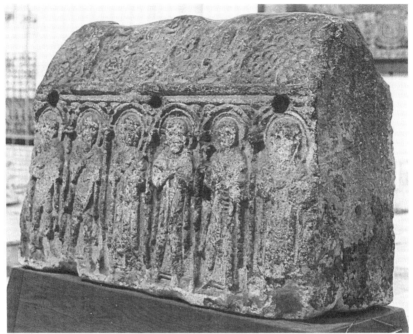

17. The Hedda stone, Peterborough Cathedral. (Photograph: Courtauld Institute.)

survive at Bakewell and a complex one with subtle iconography at Wirksworth.

The decoration of the roof of the monument consists of panels containing calligraphic paired beasts whose tails interlock in symmetrical interlace. They are very close in style to the panels of the Brunswick casket.

Cramp, R. J. 'Schools of Mercian Sculpture', in A. Dornier (editor), *Mercian Studies*. Leicester University Press, 1977.

The Cropthorne cross-head, Worcestershire.

This well preserved cross-head of about AD 800 demonstrates Anglo-Saxon sculpture's occasional links with decoration in other media as well as with art on the continent. The cusped form of the arms is found in many Northumbrian crosses of the ninth century but the ornament is distinctive and may have affected local styles in western Mercia during following decades. The repertoire consists of scrolls of foliage, and birds and beasts in profile. The animals no longer inhabit the scroll as they did in the early eighth

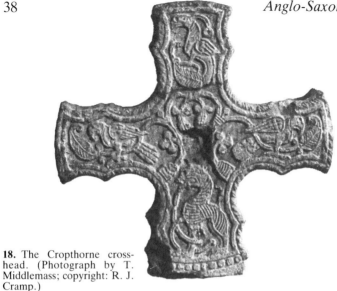

18. The Cropthorne cross-head. (Photograph by T. Middlemass; copyright: R. J. Cramp.)

century, for example at Otley and Ruthwell, but stand isolated, their tails and tongues extended to loop about their legs. Their bodies are divided into zones, each with diagonal hatching that underlines the mobile postures of the creatures. The standing beast of the lower arm sports a raised wing to make him fabulous; these animals are one stage removed from naturalism. They are found in continental painted manuscripts as well as on the metalwork in northern Europe at the end of the eighth century.

At the top of one face of the cross, the scroll terminates in a gaping beast head; this feature also has parallels in continental art, notably, as Rosemary Cramp has shown, on a stone scroll, complete with trumpet bindings similar to Cropthorne's, at Mustair. The zoned beasts prospered in the west Midlands area but by the end of the century they were appearing as far north as Bakewell in Derbyshire and poor copies turn up in Yorkshire well into the tenth century.

Such sophisticated sources for the ornament have to have a monastic context. The form and repertoire of decoration are native Anglo-Saxon, but the ornamental styles point to the kind of contacts with Carolingian Europe that scholars like Alcuin would have fostered through exchanging illuminated books.

Cramp, R. J. 'Schools of Mercian Sculpture', in A. Dornier (editor), *Mercian Studies,* 225-30. Leicester University Press, 1977.

St Alkmund's shaft, Museum and Art Gallery, Derby.
This shaft has sometimes been considered as Viking work
because of the animal ornament. The flat appearance and
contoured outlines of the design to some degree resemble Jellinge
style treatment, but their substantial proportions differ. The
Jellinge beast is a ribbon creature with much more fettering from
his body extensions. The Derby quadrupeds are what Brøndsted
called 'the Great Anglian Beast', who stands erect, often saluting
with a front paw, his chest thrown out and his tapering neck bent
back. The birds of this style share the stiff stance and do not move
in rhythmic patterns like the Anglo-Scandinavian version. The
arched panels are also a purely Anglian feature of much Mercian
sculpture.

19. St Alkmund's shaft. (Photographs by James Lang.)

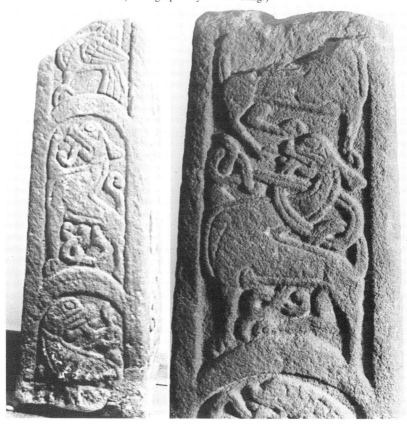

This kind of carving was influential in the Viking settlements, nonetheless, and in the north the beast is used at Gainford (County Durham) and Nunburnholme (Humberside) with Viking decorative frills such as spiral joints. Gradually the fettering grew tighter and the beasts were drawn closer so that they formed a chain. What began as a late Anglian motif succumbed to the new Scandinavian taste only in its details and in the disposition within the panel.

Kendrick, T. D. *Late Saxon and Viking Art*. Methuen, 1949.
Lang, J. T. 'Continuity and Innovation in Anglo-Scandinavian Sculpture', in J. T. Lang (editor), *British Archaeological Report* 49 (1978), figures 8.1, 8.3.

The Newgate shaft, Yorkshire Museum, York.
The sculptor of this shaft preferred fine-grained magnesian limestone for his monuments. Two grave-slab fragments from the city have been identified as his work, one from Clifford Street, the other from the Coppergate excavation where a tenth-century context was established for its find spot. The texture of the stone has allowed for the tooling marks and lay-out lines for the design to survive, so the work of this 'York Master' provides important information about the techniques of making the monuments. Such marks would have been concealed by gesso and paint, traces of which remain on his stones. The design was constructed on a grid based on drilled fix-points. Compasses were used to draw the arcs, and the initial outlines were mapped out with a simple punch. The relief carving was accomplished with chisels and gouges, the final polish being achieved with an abrasive stone. These tools and the soft stone permitted deep carving and concave planes in the old Anglian manner (see Otley).

The shaft was surmounted by a lost cross-head; the hole for its iron stay is partly run with lead. The York Master's model for the Newgate shaft was the Nunburnholme cross (Humberside), whose head fitted the shaft by means of a mortise and tenon joint. The frieze above the arched panels is also taken from Nunburnholme; an angel at each corner reaches down to suspend the arches, the wings accommodated to the spandrels.

The animal ornament owes something to the profile Jellinge beasts of Anglo-Scandinavian carvings but they are treated with a freedom and sense of space that elevate the sculptor above slavish conformity. He also preserved the Anglian tradition in carving a portrait of Christ with dished halo adjacent to his beast-chain panels.

Cramp, R. J., and Lang, J. T. *A Century of Anglo-Saxon Sculpture,* 15 (1977).

Lang, J. T. 'Continuity and Innovation in Anglo-Scandinavian Sculpture' in J. T. Lang (editor), *British Archaeological Report* 49 (1978).

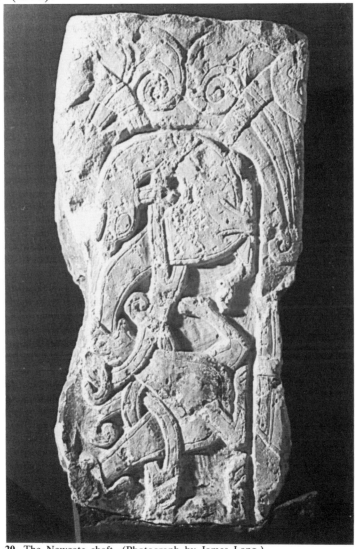

20. The Newgate shaft. (Photograph by James Lang.)

The Gosforth cross, Cumbria.

The most imposing of all the Anglo-Scandinavian monuments, the Gosforth cross, stands 14 feet (4.2 metres) high in its original socket in the churchyard. It is cut from a single piece of red sandstone and its gently tapering shaft is crowned with a beautifully proportioned wheel-head. It is a round shaft, with the characteristic cylindrical section in the lower half and a richly decorated upper zone cut into four flat faces. The junction is marked with a swag in the usual manner but below it the surface is covered with a net of vertebral Y-shaped elements. This motif has been associated with the Viking Borre-style ring-chain, but this unusual mesh is not found on any purely Scandinavian object. It does occur, however, on a hogback nearby at Crosscanonby and on a few metal ecclesiastical objects from Ireland.

The wheel-head also has a Celtic origin though the slim lines and slighter proportions distinguish this cross from Irish high crosses. Indeed, its form is borrowed partly from the Anglian staff rood and partly from the Celtic wheel-heads. Built into the church are two similar cross-heads, one perhaps from a similar cross which was cut down into a sundial in the eighteenth century.

There can be no doubt, however, of its Viking character when the figure carving of the upper shaft is studied, for it depicts Ragnarök, the destruction of the Norse gods. Mounted warriors punctuate a series of cameos that show the Fenris wolf escaping from his bonds to attack Odin, the punishment of the evil god Loki, who is chained beneath a venomous serpent whilst his wife catches the poison in a cup, the watchman of the gods, Heimdal, with his spear and horn, and Vithar rending the beast's jaw; all this amongst a welter of dragons. Yet the narrative ends with a carving of the Crucifixion. The iconography is odd: Christ stands gripping a rectangular frame, blood spurting from the spear wound inflicted by Longinus below. The other figure below is a very Viking lady with the trailing dress and pigtail seen in depictions of the Valkyrie of Valhalla on the Gotlandic picture stones in the Baltic and on the small amulets found in Scandinavian graves of the Viking age. The programme of the iconography at Gosforth is subtle and 'overlap' references between pagan and Christian stories abound.

In the church at Gosforth are three other monuments. A slab illustrating Thor's fishing for the world's serpent and a hogback very reminiscent of an Irish reliquary shrine with a Crucifixion carved on one end are both the work of the sculptor of the great

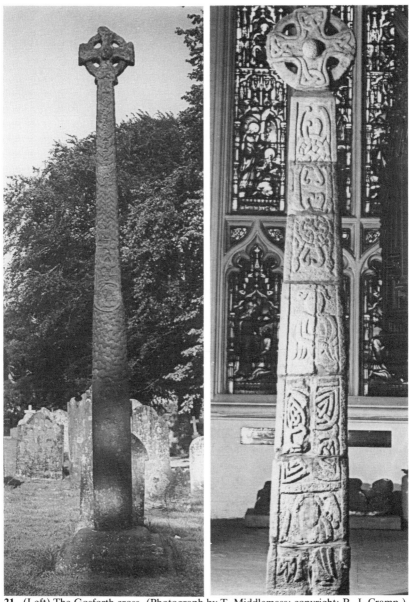

21. (Left) The Gosforth cross. (Photograph by T. Middlemass; copyright: R. J. Cramp.)
22. (Right) The Leeds cross. (Photograph by A. Wiper; copyright: R. J. Cramp.)

cross, who merits the title of the 'Gosforth Master'.

Calverley, W. S. *Early Sculptured Crosses, Shrines and Monuments in the Diocese of Carlisle.* Titus Wilson, Kendal, 1899. See pages 139 ff.

Berg, K. 'The Gosforth Cross', *Warburg and Courtauld Institute Journal*, XXI (1958), 27-43.

Bailey R. N., and Lang, J. T. 'The Date of the Gosforth Sculptures', *Antiquity*, XLIX (1975), 290-3.

The Leeds cross, Leeds Parish Church.

The Leeds shaft in the parish church, together with fragments in the City Museum, represents the ecclesiastical patronage which continued in certain areas within the Viking settlements. The wheel-head, though contemporary, belongs to a different cross. The shaft is panelled with very flat carvings which make up an iconographic scheme that reads upwards from the base. On the north face the lowest panel shows Weland the smith bound in his flying contrivance and surrounded by his tools. Above his head he holds a woman by her hair and the train of her dress. There are identical versions of this at two other northern sites: Sherburn and Bedale (North Yorkshire). Weland is depicted on the Franks casket at a much earlier period but the associated ornament of the Leeds shaft indicates a tenth-century date and therefore a more probable Scandinavian source. The smith was a hero rather than a god and he fits into an ecclesiastical programme. The base of the south face shows a figure in a wing-like cloak holding a sword. He is sometimes interpreted as Odin though Weland's attributes fit just as well. Above him is a winged cherub and the saint above had an eagle surmounting his halo, St John the Evangelist. The theme of flight is used to interrelate heroic and Christian iconography in a more cunning way than a simple juxtaposing of two motifs, like the Crucifixion and Sigurd's heart roasting at Kirby Hill (North Yorkshire).

The loose ring-knot with floating tendrils is a development of Anglo-Scandinavian interlace fashions; it has local parallels as well as Manx ones. The combination of English and Viking elements is particularly strong on this shaft. Vine-scrolls and ring-knots, Christian and heroic combine to make it thoroughly Anglo-Scandinavian in spirit.

Collingwood, W. G. 'The Early Crosses of Leeds', *Thoresby Society*, 22, 266-338.

Lang, J. T. 'Sigurd and Weland in Pre-Conquest Carving from

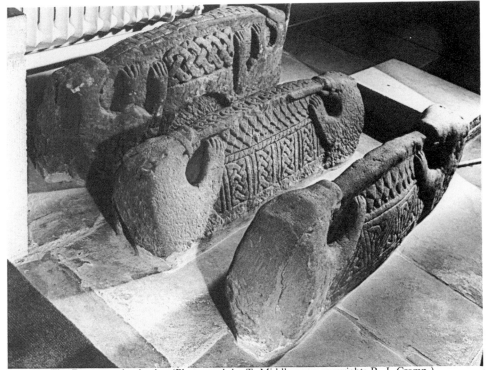

23. The Brompton hogbacks. (Photograph by T. Middlemass; copyright: R. J. Cramp.)

Northern England', *Yorkshire Archaeological Journal,* 48, 83-94.

The Brompton hogbacks, Brompton, North Yorkshire.

In the tenth century large areas of North Yorkshire and Cumbria were settled by Norse-Irish Vikings who raised great numbers of crosses in the Anglian and Celtic manner. They did innovate, however, and in Allertonshire in North Yorkshire they began carving three-dimensional recumbent monuments in the form of vernacular long-houses, with curved roof ridges, bowed walls and shingled roofs. Often the ends of the stone were embellished with large inward-facing animals, sometimes like bears and muzzled. Hogbacks are rare in being completely three-dimensional sculpture, though the form was short-lived.

Their origin lies in metal house-shaped shrines, one at Gosforth in Cumbria closely resembling a reliquary casket from Ireland, but they did not evolve from local Anglian recumbent

grave covers. They should be compared with the York Minster grave slabs, especially with regard to the end-beasts. The distribution of hogbacks is restricted to northern England with a few outliers in the north Midlands and a strange Scottish development evolved into the Romanesque coped stones.

The Brompton hogbacks are probably the earliest and certainly the most expertly carved. As the type progressed the end-beasts became smaller and more dragonesque, and the sides carried illustrative scenes of pagan mythology. Only one or two hogbacks have Christian iconography. Yet there is some evidence for crosses standing at each end of the hogback over the grave, and at Penrith (Cumbria) the 'Giant's Grave' preserves an arrangement of two crosses and four hogbacks that was recorded as far back as the seventeenth century.

Though there are local variants, due largely to regional geology, the hogback's presence on both sides of the Pennines proves a common cultural tradition to east and west in Northumbria, and challenges the notion of a separation of 'Danish' and 'Norwegian' areas. There are important groups of hogbacks at Lowther and Gosforth in Cumbria, Sockburn in County Durham and Lythe in North Yorkshire. Some from Brompton are in the Greenwell Collection in Durham Cathedral Library.

Collingwood, W. G. *Northumbrian Crosses of the Pre-Norman Age,* 164 ff. Faber, 1927.

Lang, J. T. 'The Hogback', *Studies in Anglo-Saxon Archaeology and History,* III (1984).

The Hickling hogback, Hickling, Nottinghamshire.

This complete hogback is the epitome of the eclectic habits of pre-Conquest sculptors, especially in the regions of Viking penetration. Its form derives from the more northerly hogbacks at Brompton: the roof ridge is bowed and clutched at each end by muzzled bears. However, its taper and low sill are echoes of the sarcophagus lid which occurs as far north as Durham and as far south as Ramsbury in Wiltshire. The superimposed cross and the small rectangular panels which are dependent upon it can be matched by the York Minster grave slabs, though the expanded arms have rather later parallels. A variety of small, isolated profile beasts with interlacing body extensions fill the panels, an occasional pellet serving as a response to *horror vacui,* an Anglo-Scandinavian trait. The particular form of the animals is close to those on the Desborough shaft further south in Northamptonshire.

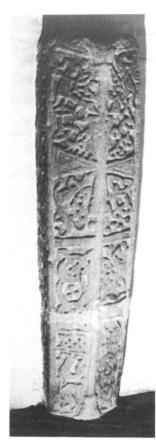

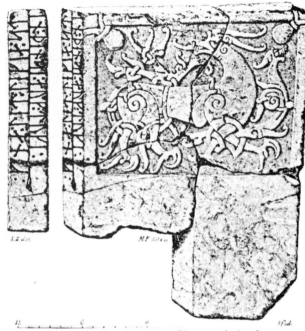

24. (Left) The Hickling hogback. (Photograph by James Lang.)
25. (Right) The St Paul's slab.

A third type of recumbent monument, the coped grave cover, may also be reflected in the shallow roof pitch of the Hickling stone. Despite so many obvious borrowings and influences, the monument has its own character and is very distinctive in its own locality; it is unique for the Midlands and different enough from its Northumbrian models.

Hill, du Boulay. 'Pre-Norman Churches and Sepulchral Monuments of Nottinghamshire', *Archaeological Journal,* 73 (1961), 195-206.

Lang, J. T. 'Continuity and Innovation in Anglo-Scandinavian Sculpture' in J. T. Lang (editor), *British Archaeological Report* 49 (1978), 145-72.

The St Paul's slab, Museum of London.

The runic inscription on the edge of this slab — 'Ginna and Toki had this stone raised' — and the superb running stag in Ringerike style confirm the Scandinavian character of this monument. Its animal ornament is in the mainstream of late Viking styles: a large, moving quadruped in profile contending with a serpent. Extensions from the body erupt in fans and take on a foliate appearance, whilst the whole composition seems to respond to a vigorous gale. Such Ringerike beasts are found on the Scandinavian ships' vanes and on some incised sculpture such as the Vang stone in Norway. The style in England is confined to the south, especially to centres where Knut held sway.

In the corners of the panel are palmette lobes, another manifestation of the shift from animal to vegetable ornament in the eleventh century. They are a common feature of contemporary Swedish runestones. It is illuminating to compare the St location yet represent very different artistic traditions. The late Viking styles survived longer in Ireland but the new Romanesque, already introduced into Edward the Confessor's Westminster Abbey, was to be the stronger contender in southern England. A comparison with the Durham cross-heads also shows how the south and the north were culturally distinct at this period.

Kendrick, T. D. *Late Saxon and Viking Art,* 99-100. Methuen, 1949.

Rice, D. Talbot. *English Art 871-1100,* 127-8. 1952.

The Romsey rood, Romsey Abbey, Hampshire.

This large carving of the Crucifixion is built into an exterior wall of the Romanesque abbey at Romsey. It is the best preserved of a group of such monumental sculptures in the southern counties and belongs to the latest phase of the pre-Conquest period. Its cutting techniques and almost three-dimensional relief put it close to European Romanesque work, demonstrating that Anglo-Saxon sculpture might have evolved naturally into mainstream styles without the catalyst of the Norman Conquest.

The carving is composite and consists of a number of blocks fitted together. One hundred years later this technique was used in the region for the Chichester Lazarus panels, which display a similar mode of tubular rendering of the limbs. The style is naturalistic, even classical, and there is nothing of the heavy stylisation often found in earlier sculpture. This may be a

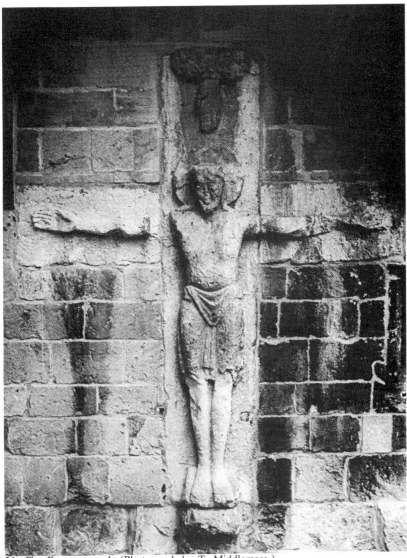

26. The Romsey rood. (Photograph by T. Middlemass.)

response to continental impulses, a likely possibility in the southern counties, or it could be an effect of the Winchester reforms of the late tenth century and the court styles seen in southern manuscripts of that period.

The iconography of the Crucifixion is of particular interest because the rigid stance of Christ, with straight limbs and head erect, echoes the early representations where he is more a Majestas than a suffering servant. That depiction was typical of insular art until the late tenth century when, slowly, the fully clothed, regal Christ gave way to the hanging body draped only in a loin cloth. Carolingian models, perhaps in ivory, influenced this change. The Romsey rood represents a halfway house between the two traditions.

Its original position in the earlier church must be uncertain but it surely had an architectural context owing to its size and the manner of its erection in a wall. Nearby, at Breamore, a much defaced rood with flanking figures survives in the porch; traces of paint are to be found on it. Another at Headbourne Worthy (Hampshire) stands high up on what was the exterior west wall of the nave.

Kendrick, T. D. *Late Saxon and Viking Art,* 48-9. Methuen, 1949.

Rice, D. Talbot. *English Art 871-1100,* 98. 1952.

The Durham cross-heads, Durham Cathedral Library.

A set of richly carved cross-heads was recovered from the foundations of the chapter house of Durham Cathedral, a building which was begun in the late eleventh century. The pieces are therefore among the very few from a sealed archaeological context and, since the Community of St Cuthbert did not arrive on the site until 995, they can with reasonable confidence be dated within a fifty-year span. Three of the four very closely resemble each other in form, style and technique.

They are free-armed crosses with a large central medallion which, with the arm panels, carries ecclesiastical iconography: the Lamb, the Crucifixion, (?) baptism, evangelists' symbols and clerics. These scenes and the traditional style of cross-head owe nothing to the Anglo-Scandinavian sculpture only a few miles away south of the Tees, where the patronage was often secular and the cross of the wheel type. The explanation lies in the survival of Anglian traditions in northern Northumbria, where the Cuthbert Community, severed from the Saxon south by the Viking settlements, persevered in some isolation.

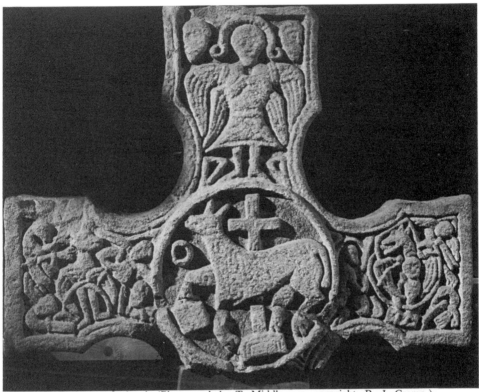

27. Durham cross-head. (Photograph by T. Middlemass; copyright: R. J. Cramp.)

Compared with ninth-century work in Northumbria, the quality is poor but confident. It has been suggested that templates were used in the construction of the design since many of the details match in size and shape both on individual monuments and within the group. There are no other local carvings quite like the Durham crosses so they comprise the work of an identifiable workshop in the monastery in the early decades of the eleventh century.

Haverfield, F. J., and Greenwell, W. *Catalogue of the Sculptured and Inscribed Stones in the Cathedral Library, Durham,* 79-84. T. Caldcleugh, Durham, 1899.

Coatsworth, E. 'The Four Cross-heads from the Chapter House, Durham', in J. T. Lang (editor), 'Anglo-Saxon and Viking

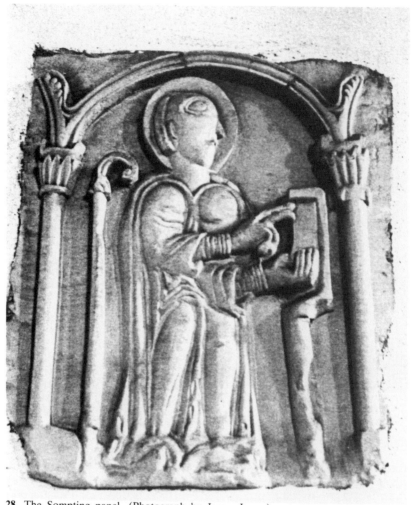

28. The Sompting panel. (Photograph by James Lang.)

Sculpture and its Context', *British Archaeological Report* 49 (1978), 85-96.

Bailey, R. N. 'The Chronology of Viking Age Sculpture in Northumbria', in J. T. Lang (editor), *British Archaeological Report* 49 (1978), 182.

Bailey, R. N. *Viking Age Sculpture in Northern England*, 249-51. Collins, 1980.

The Sompting panel, Sompting, West Sussex.
The late Saxon church at Sompting, famous for its Rhenish helm tower, was originally sumptuously decorated. Fragments of string-course friezes survive, their acanthus decoration reflecting southern English manuscript motifs of the end of the tenth century and unsurprisingly looking to Carolingian Europe as its source. The capitals of the present tower arch are equally florid compared with the plainness of many southern counterparts. Their panache of plumes, though crudely accomplished, is a harbinger of the Normandy type which Lanfranc was to introduce into the earliest Norman phase at Canterbury. Only the tubular scroll is a faint memory of the Saxon vine-scroll tradition.

The panel's function may also have been architectural embellishment, as it is rather small for part of a shrine. A closure slab for a screen or even another frieze is a possibility. The figure stands, holding a crozier, beneath an arch, like those of the Breedon shrine and the Hedda stone, in the continuing tradition of classicism. Whilst the Sompting figure is more formalised, his stylisation lies in the relief treatment, for he is built up of convex domed elements, for example the head and the shoulder, in a manner often found in Romanesque sculpture. The body is conceived in terms of related masses, a rare approach in pre-Conquest work.

Another forerunner of Romanesque style is the handling of the drapery. This, too, is disposed in zones without any attempt at naturalistic folds. The gown clings to the limbs and has a surrounding ridge which, whilst not quite Romanesque damp-fold, is perhaps a sculptural reflex of the drapery handling in the Winchester-style Benedictional of St Aethelwold.

These features, when considered along with the Romsey rood, suggest that Romanesque sculptural styles would have arrived naturally in the evolution of English carving without the catalyst of the Norman Conquest. It is natural that these mainstream European traits are to be found chiefly in the south coast counties.

Rice, D. Talbot. *English Art 871-1100,* 107. 1952.

6
Places to visit

Most pre-Conquest sculpture remains in the churches where it was discovered, either built into the fabric or sometimes still standing in the churchyard. The sites listed are merely a selection of places where the sculpture is important or prolific. Intending visitors are advised to ascertain dates and times of opening before making a special journey.

Collections

Bede Monastery Museum, Jarrow Hall, Church Bank, Jarrow, Tyne and Wear NE32 3DY. Telephone: 091-489 2106. Important monuments and the lectern from Bede's monastery are in the museum and also in the porch of St Paul's church. See Cramp, R. J., *Early Northumbrian Sculpture,* Jarrow Lecture, 1965.

British Museum, Great Russell Street, London WC1B 3DG. Telephone: 01-636 1555. A few choice pieces stand in the early medieval gallery.

Canterbury Cathedral, Canterbury, Kent. The Crypt Museum holds the coloured fragments of the Reculver sculptures. See Peers, C. R., 'Reculver: its Saxon Church and Cross', *Archaeologia,* 77 (1927).

Derby Museums and Art Gallery, The Strand, Derby DE1 1BS. Telephone: 0332 3111. Ninth-century carvings from St Alkmund's which strongly influenced Viking period sculpture. See Routh, R. E., in 'Further reading'.

Durham Cathedral, Durham. The Monks' Dormitory houses the Greenwell Collection of carvings, chiefly from Northumbria. This is a very important collection and includes casts of the Ruthwell and Bewcastle crosses. See Haverfield, F. J., and Greenwell, W., in 'Further reading'.

Hexham Abbey, Hexham, Northumberland. The north choir aisle is a museum containing the Spital cross and Wilfridian to Viking pieces are represented in niches in the nave. Acca's cross stands almost complete in the south transept. See Cramp, R. J., 'Early Northumbrian Sculpture at Hexham', in D. P. Kirby (editor), *St Wilfrid at Hexham,* 1974.

Kirkmadrine Stones, Wigtownshire, Galloway. 8 miles south of Stranraer. Though in Scotland, this monastic centre produced

considerable quantities of sculpture in the Anglian tradition. The collection is housed in the porch of a disused chapel.

Lindisfarne Priory, Holy Island, Northumberland. Telephone: 028989 200. English Heritage. The site museum has a fine collection including the 'pillow stones'. See Peers, C. R., 'The Inscribed and Sculptured Stones of Lindisfarne', *Archaeologia,* 74 (1924).

Manor House Museum and Art Gallery, Castle Yard, Ilkley, West Yorkshire LS29 9DT. Telephone: 0943 600066. Smaller fragments of ninth-century crosses add to the three splendid shafts in the church. See Collingwood, W. G. (1907-14), in 'Further reading'.

Museum of Antiquities of the University and the Society of Antiquaries of Newcastle upon Tyne, The University, Newcastle upon Tyne NE1 7RU. Telephone: 091-232 8511 extension 3844 or 3849. Sculpture from Bernician sites, much of it in store, includes fine pieces from Rothbury and Nunnykirk. See Cramp, R. J., and Miket, R., *Catalogue of the Anglo-Saxon and Viking Antiquities,* 1982.

Royal Museum of Scotland, Queen Street, Edinburgh EH2 1JD. Telephone: 031-225 7534. The sculpture gallery contains some fine Anglian pieces. See Allen, J. Romilly, *The Early Christian Monuments of Scotland,* 1903.

Victoria and Albert Museum, Cromwell Road, South Kensington, London SW7 2RL. Telephone: 01-938 8500. The magnificent Easby cross. See Longhurst, M., 'The Easby Cross', *Archaeologia,* 81 (1931).

Yorkshire Museum, Museum Gardens, York YO1 2DR. Telephone: 0904 29745.

Sites (usually churches)
Bedfordshire: Elstow.
Cambridgeshire: Barnack, Castor, Fletton, Peterborough.
Cheshire: Chester (St John's), Neston, Sandbach, Winwick.
Cleveland: Hart, Kirklevington.
Cumbria: Aspatria, Beckermet, Bewcastle, Dacre, Gosforth, Irton, Kirkby Stephen, Lowther, Penrith.
Derbyshire: Bakewell, Bradbourne, Derby, Eyam, Repton, Wirksworth.
Dorset: Winterbourne Steepleton.
Dumfriesshire: Ruthwell.
Durham: Chester-le-Street, Escomb, Gainford, St Andrew Auckland, Sockburn.

Gloucestershire: Daglingworth, Deerhurst, Gloucester, Newent.
Hampshire: Breamore, Headbourne Worthy, Romsey, Winchester.
Hereford and Worcester: Cropthorne.
Humberside: Crowle, Nunburnholme, Sutton on Derwent.
Kent: Canterbury (Reculver statues in the Cathedral Crypt, and St Augustine's Abbey).
Lancashire: Halton, Heysham, Hornby, Lancaster.
Leicestershire: Breedon-on-the-Hill.
Lincolnshire: South Kyme.
Norfolk: Norwich.
Northamptonshire: Desborough.
Northumberland: Hexham, Norham, Rothbury, Simonburn.
Nottinghamshire: Hickling, Shelford, Stapleford.
Staffordshire: Leek.
Sussex, West: Sompting.
West Midlands: Wolverhampton.
Wiltshire: Bradford-on-Avon, Britford, Codford St Peter.
Yorkshire, North: Bedale, Brompton, Burnsall, Croft, Cundall, Hackness, Hovingham, Kirkdale, Lastingham, Lythe, Masham, Middleton, Ripon, Sherburn, Stonegrave, Whitby, York.
Yorkshire, West: Collingham, Dewsbury, Ilkley, Leeds, Otley.

7
Further reading

Until the completion of the British Academy's *Corpus of Anglo-Saxon Sculpture,* the fullest descriptive lists of the carvings lie in the county archaeological journals and sometimes in the introductory volumes of the *Victoria County History.* The most important county articles are listed below.

General reading
Bailey, R. N. *Viking Age Sculpture in Northern England.* Collins, London, 1980.
Brown, G. Baldwin. *The Arts in Early England,* volumes V and VI, 2. John Murray, London, 1921 and 1927.
Collingwood, W. G. *Northumbrian Crosses of the Pre-Norman Age.* Faber, London, 1927.
Cramp, R. J., and Lang, J. T. *A Century of Anglo-Saxon Sculpture.* Frank Graham, Newcastle, 1977.
Kendrick, T. D. *Anglo-Saxon Art to 900.* Methuen, London, 1938.
Kendrick, T. D. *Late Saxon and Viking Art.* Methuen, London, 1949.
Lang, J. T. (editor). 'Anglo-Saxon and Viking Age Sculpture and its Context'. *British Archaeological Report* 49, Oxford, 1978.
Thompson, F. H. (editor). *Studies in Medieval Sculpture.* Society of Antiquaries, 1983.

Regional surveys
Bailey, R. N., and Cramp, R. J. *Corpus of Anglo-Saxon Stone Sculpture,* volume II, 'Cumberland and Westmorland'. Oxford University Press, 1988.
Calverley, W. S. *Early Sculptured Crosses, Shrines and Monuments in the Diocese of Carlisle.* Titus Wilson, Kendal, 1899.
Collingwood, W. G. 'Anglian and Anglo-Danish Sculpture in the Ridings of Yorkshire', *Yorkshire Archaeological Journal,* 19, 20, 21 and 23 (1907-14).
Cramp, R. J. *Corpus of Anglo-Saxon Stone Sculpture,* volume I 'County Durham and Northumberland'. Oxford University Press, 1984.
Cramp, R. J. 'Schools of Mercian Sculpture', in A. Dornier (editor), *Mercian Studies,* 191-233. Leicester University Press, 1977.

Haverfield, F. J., and Greenwell, W. *A Catalogue of the
 Sculptured and Inscribed Stones in the Cathedral Library,
 Durham.* T. Caldcleugh, Durham, 1899.
Langdon, A. G. 'Early Christian Monuments: Cornwall', *Victoria County History,* I, 1906.
Routh, R. E. 'A Corpus of the Pre-Conquest Carved Stones of
 Derbyshire', *Archaeological Journal,* XCIV (1938), 1-42.

Index

Page numbers in italic refer to illustrations.